USA

FROM SPACE

Anne-Catherine Fallen

FIREFLY BOOKS

A FIREFLY BOOK

USA From Space
Copyright © 1997 Firefly Books Ltd.

PUBLISHED BY
Firefly Books Ltd.
3680 Victoria Park Avenue
Willowdale, Ontario
Canada M2H 3K1

PUBLISHED IN THE UNITED STATES BY
Firefly Books (U.S.) Inc.
P.O. Box 1338, Ellicott Station
Buffalo, New York 14205

PRODUCED BY
Charles O. Hyman, Visual Communications, Inc., Washington, D.C.

DESIGNED BY
Kevin Osborn, Research & Design, Ltd., Arlington, Virginia

PRINTED AND BOUND IN CANADA BY
Friesens, Altona, Manitoba

Cataloguing in Publication Data

Fallen, Anne-Catherine
 USA from space

ISBN 1-55209-159-7 (bound)
ISBN 1-55209-157-0 (pbk.)

1. United States Photographs from space - Juvenile literature. 2. United States - Geography -
Juvenile literature. 3. Physical geography - United States - Juvenile literature.
I. Title.

E161.3.F34 1997 j917.3'0022'2 C97-930890-9

Contents

Creating a Living Map

Since our ancestors first learned to climb trees, we have been trying to get a better view of the Earth around us. Whether to watch for enemies and bad weather or simply to satisfy curiosity about the land, we've constantly looked for ways to build higher and see farther. More than two hundred years ago, the first hot-air balloon freed us to explore our planet from above. Today, the airplane and the jet plane let us travel to the edge of the atmosphere, and rockets carry people and satellites into outer space.

Along with the desire to discover the world from the air came the need to bring back pictures of the view. The first balloonists brought paper and pencil with them to draw the landscape. In the 1850s, with a new device called a camera, balloonists took the first aerial photos. During World War I, biplanes captured enemy positions on film. Technology advanced rapidly after that, and aerial photography became an important tool for mapmakers, geologists, farmers, and foresters. By the end of World War II, scientists had invented new ways to gather information that included radar, thermal, and infrared imaging. These would evolve into the basic ways we study the Earth from outer space.

LEFT: *The Space Shuttle* Columbia *climbs skyward on a 1996 mission. Shuttles routinely carry satellites into space. Astronauts are trained to launch, retrieve, and repair them.*
RIGHT: *A satellite view of Cape Canaveral, Florida. The launch pads are in the "elbow" to the right of the image.*

When the U.S. space program started in the 1960s, the National Aeronautics and Space Administration (NASA) developed plans for satellites that would circle the Earth in a regular and predictable orbit and collect information about the environment. In 1972, the first of these, Landsat 1, was launched on the tip of a huge Delta rocket. This satellite became a remote eyeball moving around the planet, sending back everything it "saw."

Since then, four more Landsat satellites and a number of satellites from other countries have joined Landsat 1 in space. Hundreds of miles above the Earth, a typical satellite makes about 14 orbits a day, taking 233 orbits to return to the same spot. With special instruments, satellites record and send information to stations on the ground. The pictures that we receive are not photographs, because they don't come from cameras that use film. Satellites use remote sensing devices — "remote" because no one is there to

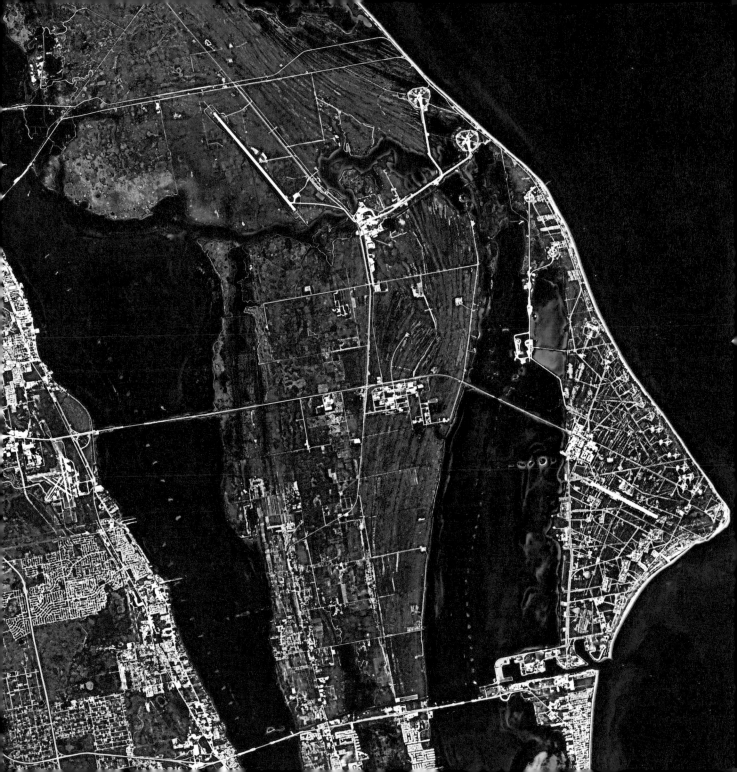

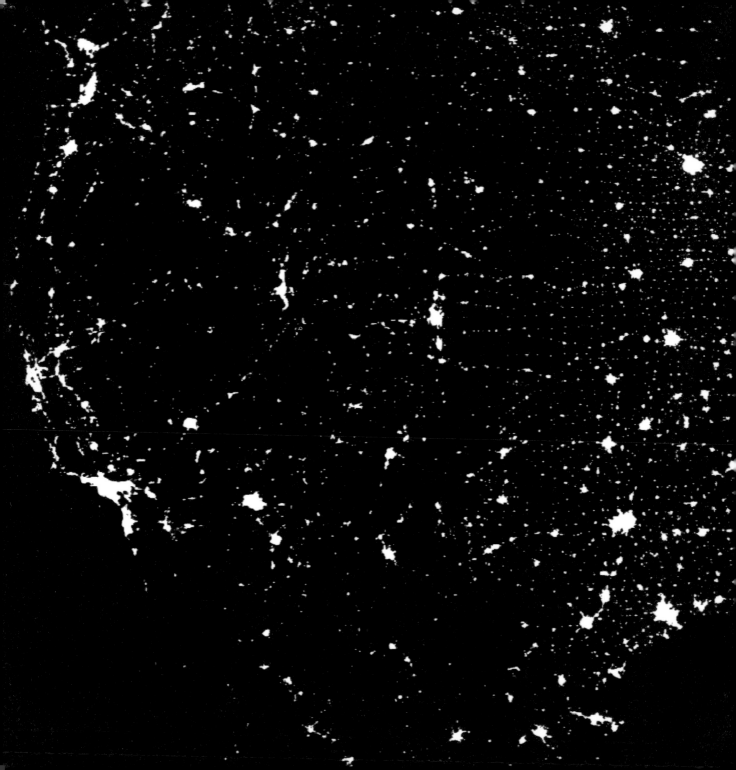

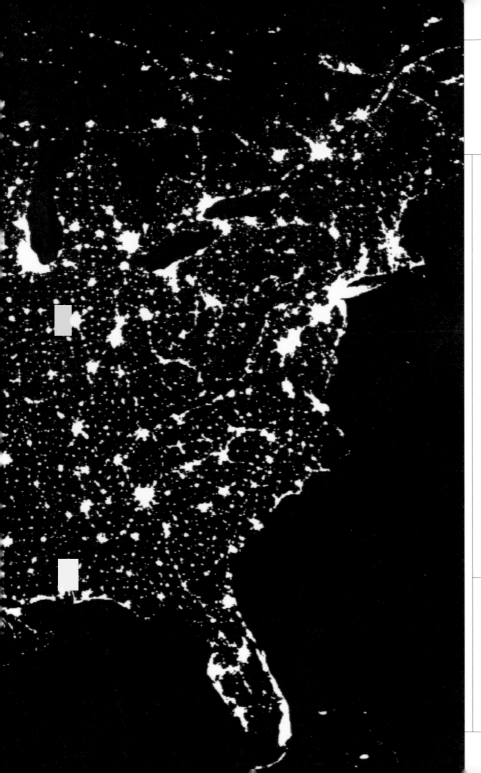

operate them, and "sensing" because they use different instruments to measure the energy reflected off the Earth's surface. Some of these instruments measure heat (thermal energy), others use radar to see under the surface, and still others record visible green and red light waves and invisible infrared waves. Once the data are collected from a satellite, an image is created by giving each of the different measurements a color and then layering them on top of one another. Since the bright color is artificial, the final pictures are called false-color composites.

The surprising images included in *USA From Space* show us a living map of the United States. The amazing details let us see our cities and countryside today, but they also show us the changes caused by pollution, population, and natural disasters. If we pay attention to this information, satellite images can be useful tools to help us monitor the health of our planet.

LEFT: *Cities and towns shine out on a satellite composite made from data collected during 231 orbits. The light patterns show where population is concentrated. On the East Coast, cities from Boston to Washington, D.C., have merged into one giant city called a megalopolis. The same is true from San Francisco to San Diego on the West Coast.*

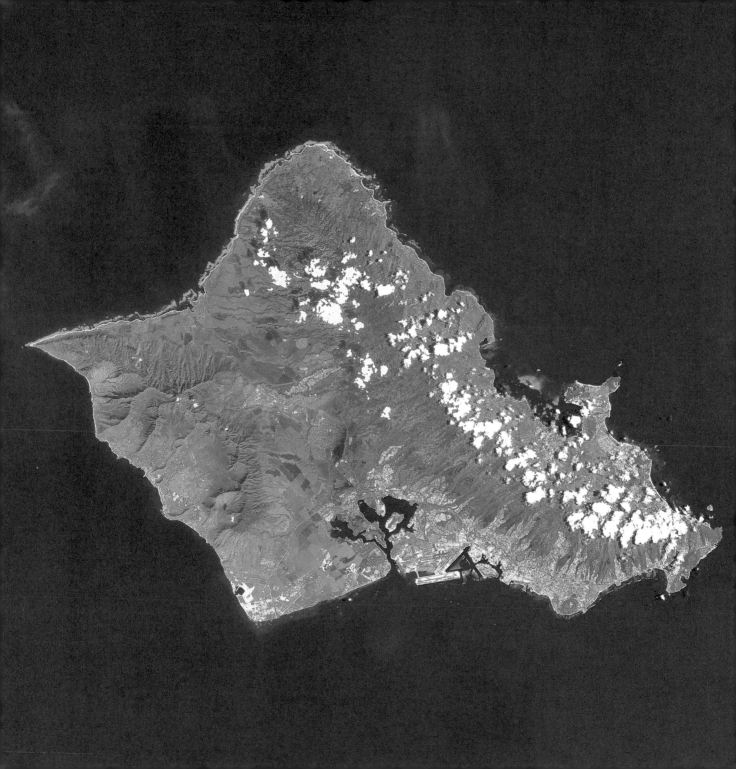

Oahu, Hawaii

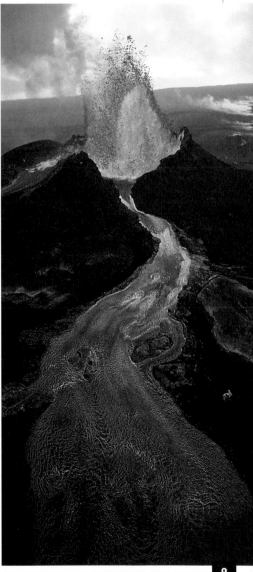

S een from space, the Hawaiian Islands gleam like emeralds scattered into a pool of water. Oahu, pictured here, is one of eight big islands among dozens that make up the state of Hawaii. Like more than 130 other Pacific islands, Oahu was created by underwater volcanoes and then shaped by wind and rain. Long ago, the winds were named trade winds because sailing ships needed them to get from port to port to trade goods.

Oahu, like its sister islands, has a mountainous interior. The mountains divide each island into a windy, wet side and a calmer, dry side. The line of clouds over Oahu shows it clearly: rain falls on the lush green areas, while the brown areas remain dry. One island, Kauai, gets 55 feet of rain a year in its mountain heights. Rainfall over the Hawaiian Islands encourages the growth of a wide variety of unusual trees and flowers, some found nowhere else on Earth.

The city of Honolulu, at the bottom of the image, is the capital of Hawaii, which became the fiftieth state in 1959. The rectangular piece of land that juts into the water is the international airport. Pearl Harbor is the bay shaped like a fan. The U.S. Navy keeps ships here to protect them from rough seas and bad weather. On December 7, 1941,

RIGHT: *Rivers of lava flow from Kilauea, the world's largest active volcano, located on the "Big Island" of Hawaii.*

Japanese warplanes bombed the ships in the harbor, causing the United States to declare war on Japan.

The Hawaiian Islands stretch for 1,300 miles northwestward, beginning at the island of Hawaii, where volcanoes still ooze lava. The Hawaiian Islands were pushed up from the bottom of the sea as intraplate volcanoes, triggered by unusually hot spots deep within the Earth. At these spots, lava pushed through the crust and hardened as it hit the cool ocean water. Liquid lava continued to rise and cool, eventually building volcanoes that formed the islands. The highest mountain on Hawaii, Mauna Loa, is 13,677 feet high. If measured from the sea floor 20,000 feet below, it would be the tallest mountain on Earth.

Katmai National Park

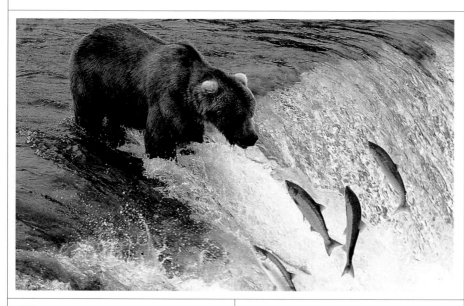

Located on the Alaska Peninsula, Katmai National Park and Preserve is a wilderness of water, fire, and ice. All 4.1 million acres of the park are captured in this satellite image. The forested coastline of Shelikof Strait, bright red against the dark water, is one of the wildest shores in all Alaska. Sea lions and seals haul out along the rocks. Whales pass along the coast. The 1989 oil spill from the tanker *Exxon Valdez* reached the beaches along Katmai, threatening many species. Oil can still be found beneath the sand.

The snow-covered mountains that follow the coast are part of the Aleutian Range. A few active volcanoes rise in the park, and alpine glaciers hug the sides of many peaks. In 1912, Katmai was rocked by one of the most powerful volcanic eruptions in recorded history, 10 times stronger than the 1980 explosion of Mount St. Helens. Ash from the blast stained clothes hanging on lines a thousand miles away. Observers thought the top of Mount Katmai had blown off, but scientists later discovered that Novarupta, a volcanic vent five miles away, was the true source of the explosion. As the vent sent melted rock and ash skyward, Mount Katmai collapsed into new underground cracks, creating a huge crater. The desolate area northwest of Novarupta became known as the Valley of Ten Thousand Smokes because of the thousands of jets of steam and gas that shot up through the compacted ash. The valley is visible in the light blue area sprinkled with clouds just beneath the lakes.

The western section of the park is an uninhabited land of lakes and marshlands fed by mountain rivers. This wilderness is the habitat of brown bears. It is estimated that between 1,500 and 2,000 bears, one of the largest protected populations in Alaska, roam throughout the park.

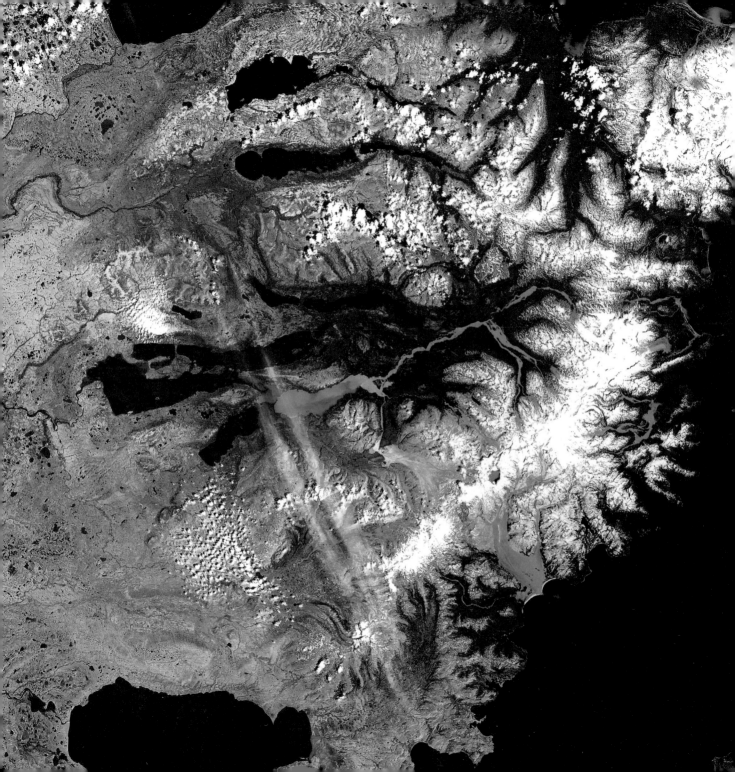

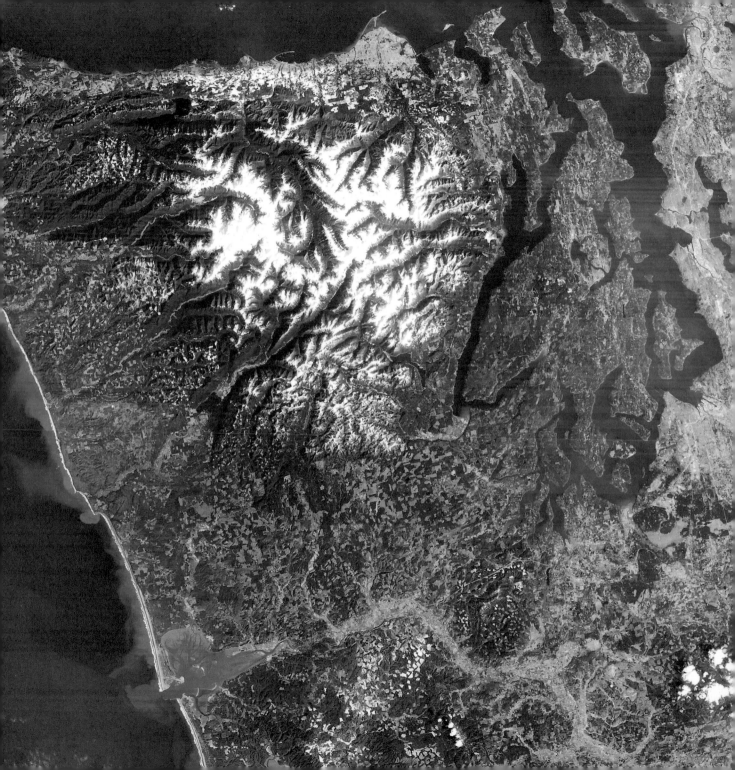

The Olympic Peninsula

On an unusually clear day, a satellite captures the forests and mountains of the Olympic Peninsula. Pacific winds bring moist air that condenses over this northwestern tip of Washington, giving it the wettest climate in the lower 48 states. The peninsula is bordered by the Pacific Ocean on the west, the Strait of Juan de Fuca on the north, and Puget Sound on the east. To the south, the Chehalis River flows into the Pacific through Grays Harbor.

The Olympic Peninsula averages 150 inches of rain a year along its west coast, making it one of the few places on Earth with a temperate rain forest. The temperature there rarely drops below freezing or gets hotter than 80°F. In the satellite image, the rain forest is dark green, clinging to the western edge of the snow-covered mountains. The peaks of the Olympic Mountains rise above the rain forest, intercepting humid Pacific air and trapping it. At lower elevations, this moisture falls as rain, nourishing the rain forest. As it slowly climbs to higher elevations, the moisture becomes snow, feeding glaciers that continue to carve the mountains. On the northeast side of the mountains, there is a rain shadow, a place that gets

RIGHT: *Mosses and ferns cling to trees in the temperate rain forest. Nearly every inch of space is used by growing plants. The dominant species, Sitka spruce and western hemlock, sometimes grow to heights of 300 feet with circumferences of 20 feet or more. The thick vegetation also provides habitats for many birds and animals.*

very little precipitation because very little gets past the peaks. Mount Olympus is the tallest of these peaks at just under 8,000 feet.

Half of the state's population lives within 50 miles of Seattle, the large urban area along the east coast of Puget Sound. Olympia, the state capital, is at the southern end of the sound. Clouds at the bottom right obscure mountains on the western edge of the Cascade Range. Mount Rainier, the highest point in Washington, is just beyond the picture's edge.

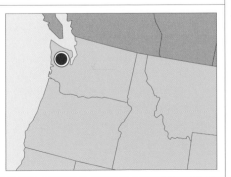

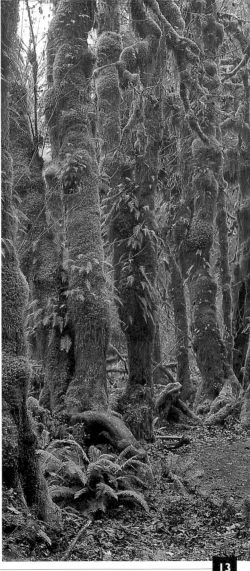

Mount St. Helens

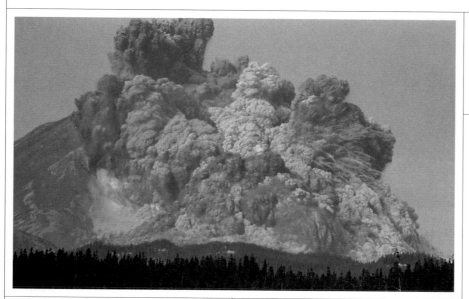

LEFT: *Traveling at a speed of 670 miles per hour, a huge cloud of steam, ash, and gas shoots out the side of Mount St. Helens as it explodes. The blast released 500 times more energy than the first atomic bomb.*

The soothing violets and greens in this image give no hint of the terrible destruction that accompanied the eruption of Mount St. Helens in the Cascade Range of Washington State. On the morning of May 18, 1980, a huge blast ripped away the north face of the mountain. Tons of rock and hot ash poured out of the crater, mixing with melted snow and soil to form a boiling, rushing river of mud. Steam and ash blew 12 miles into the air and darkened the sky for hundreds of miles around. Fierce winds knocked down trees up to 18 miles away. The explosion killed 57 people.

Mount St. Helens was a subduction volcano. It erupted because plates in the Earth's crust collided, pushing melted rock to the surface with tremendous force. The melted rock, called magma, emerged as lava and hot ash. Two other basic types of volcanoes exist. Hot-spot volcanoes, like those in the Hawaiian Islands, form when pressure pushes the magma up through weak places in the crust and lava bubbles through. Rift volcanoes, occurring mostly on ocean floors, form when plates of the Earth's crust separate, allowing the magma to rise.

The horseshoe crater, clearly visible from space, is all that is left of Mount St. Helens. Lava flowed out in a fan pattern, engulfing all the trees and wildlife in its path and filling Spirit Lake. When this image was made 11 years after the eruption, the mountain and its surroundings, in purple shades, were still completely bare. The traces of light green along the edges of the purple are new growth. The small, rectangular patches on the right are areas where trees have been clear-cut, a logging practice that removes all the trees from a piece of land at one time. The mountain is now designated a National Volcanic Monument.

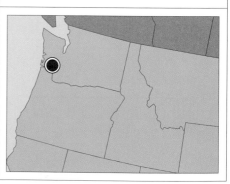

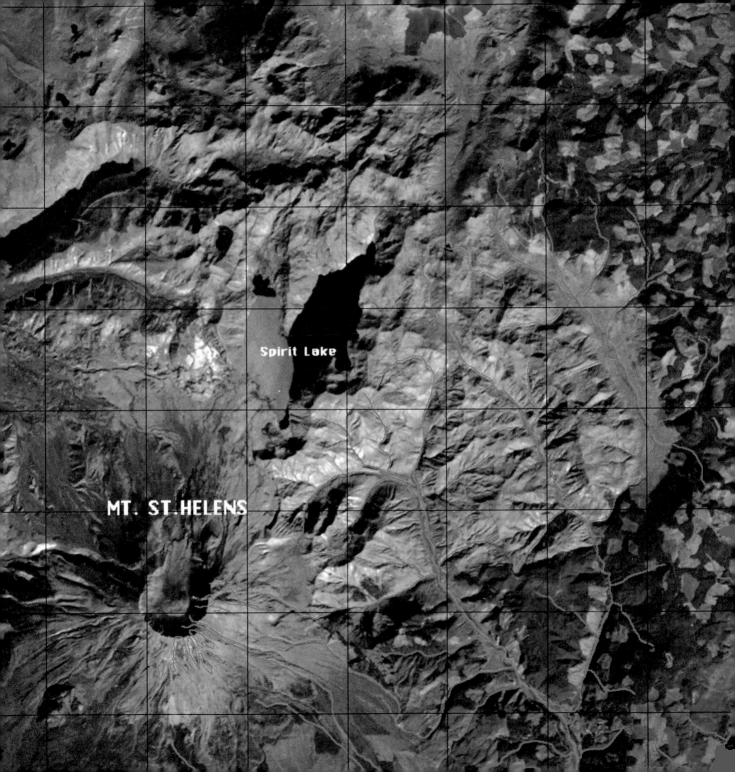

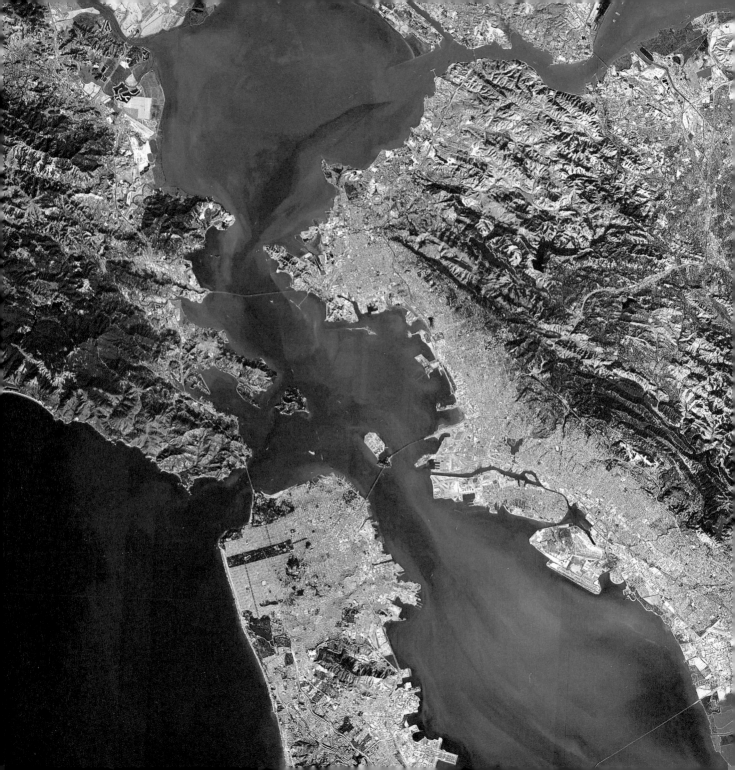

San Francisco Bay

One of the world's finest natural harbors, San Francisco Bay lies parallel to the Pacific coastline. The Golden Gate Bridge spans the entrance to the bay, connecting the city of San Francisco on the south with Sausalito on the north. Berkeley and Oakland are directly across on the eastern shore. More than 6 million people live around the bay, which is 60 miles long. Areas of light green show where most of the population is concentrated.

San Francisco sits on top of the San Andreas Fault, a boundary between two plates of the Earth's crust. Here, the Pacific plate is moving northward, grinding against the North American plate. A small part of the fault can actually be seen along the Pacific coast at the left edge of the satellite image. The San Andreas Fault stretches 700 miles through California and is the source of thousands of earthquakes a year, though most of them are so minor that no one notices. As the Earth's plates scrape against each other, strain increases along the edges. Earthquakes occur when pressure along the plates is so great that an edge suddenly shifts. The shifting releases energy, causing vibrations to travel like waves through the Earth. In the most severe earthquakes, the ground heaves up and down and side to side. Though they last only seconds, the shocks and aftershocks of an earthquake can do tremendous damage.

San Francisco has experienced several earthquakes in the past hundred years. The historic 1906 quake toppled buildings and started fires that swept through the city, leaving tens of thousands of people homeless. In 1989, the Loma Prieta earthquake, centered south of the city, demolished bridges and houses. The worst damage occurred in places around the bay where buildings were erected on unstable landfill.

RIGHT: *Forty-two people were killed when the upper deck of this Oakland freeway collapsed during the Loma Prieta earthquake in 1989.*

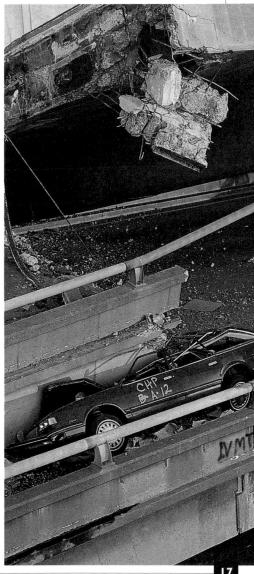

The Grand Canyon

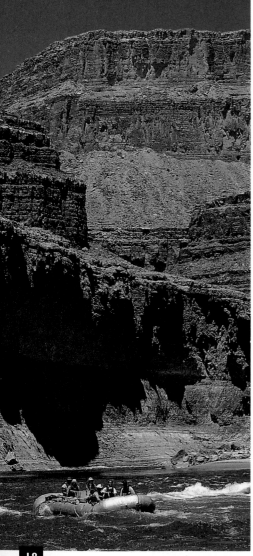

A deep blue line etched in pink rock, the Colorado River winds southwest through the Grand Canyon in Arizona. One mile deep and up to 18 miles wide, the canyon is so big that it can be seen even from high in space. Figuring in all the twists of the river, it is 277 miles long.

At sunrise and sunset, when light accents the colors and shapes the shadows, the rock walls of the Grand Canyon retell the ancient and dramatic story of the Earth's formation. The powerful Colorado River carved the Grand Canyon over the past 5 or 6 million years. Sand and gravel carried by the rushing water acted like a scrub brush, gouging away the rock inch by inch. The canyon walls are striped with horizontal layers of colored rock. Each layer represents a geologic era, when volcanoes and seas, sediment and erosion shaped the land. Some of the oldest rocks on the planet, close to 2 billion years old, are found at the bottom of the canyon. At the top, almost 8,000 feet above sea level, is a layer of limestone formed from marine animals.

Erosion is also responsible for the spectacular variety of shapes in the

LEFT: *A rafting trip through the Grand Canyon is an exciting way to get a close look at the canyon walls, where the Earth's geologic history is exposed in layers of rock. Rafters can also discover the ruins of ancient Anasazi communities.*

Grand Canyon. Harder rocks, such as sandstone and limestone, erode into vertical cliffs. Softer rocks, such as shale, form slopes and terraces.

The countryside surrounding the Grand Canyon is high plateau, a mostly flat, dry land. The tops of the plateaus, covered with sparse vegetation, show up as broad green areas in this satellite image. Most of the canyon is preserved as a national park, which is bordered by Indian reservations and national forests. At the far left, the dark waters of Lake Mead mark the western boundary of the Grand Canyon.

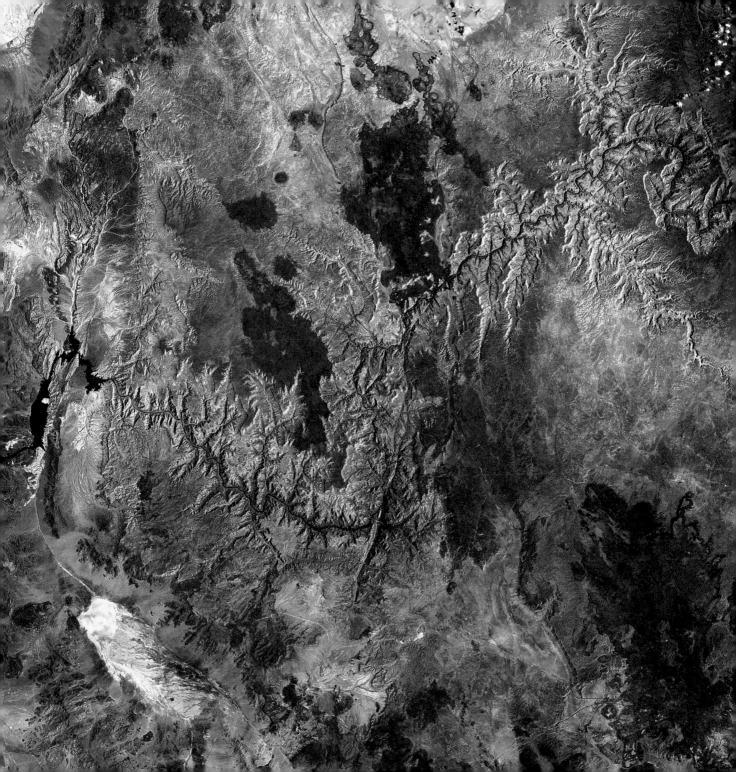

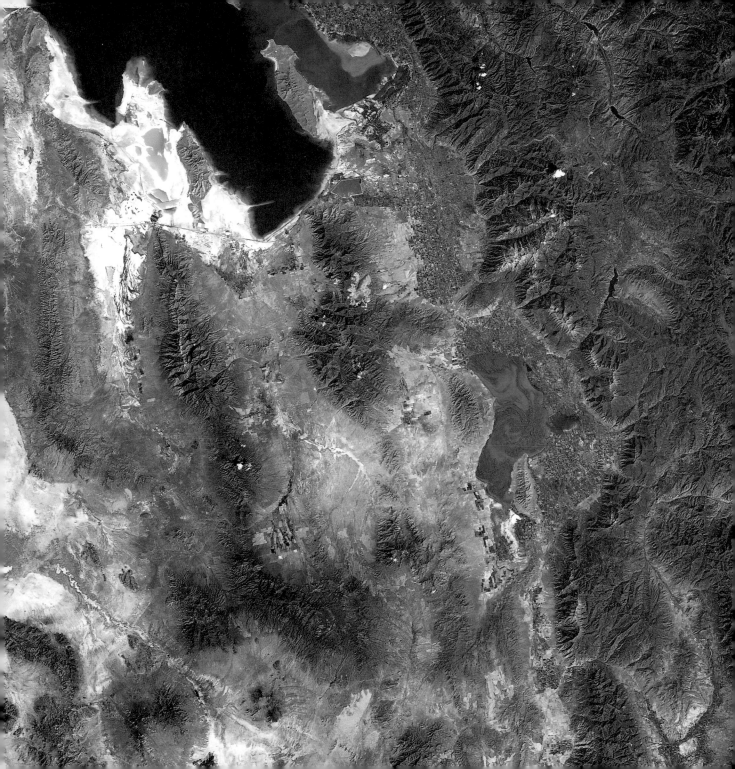

Salt Lake City

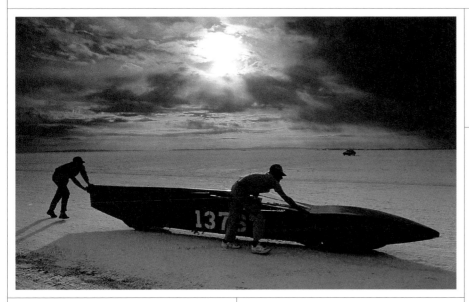

Marked by wave patterns and wide terraces, the deserts of western Utah resemble an ocean floor. About 30,000 years ago, when the climate was wetter and cooler, this area was covered by Lake Bonneville, a vast freshwater sea. The mountains surrounding it were like the sides of a tub. As centuries passed, the climate slowly changed, becoming hotter and drier. Water drained away to the south until what remained was trapped, with nowhere to flow. The Great Salt Lake, at the top of the picture, and Utah Lake, just below it, are among a handful of lakes that survived.

The Great Salt Lake is the largest body of salt water in the Western Hemisphere and is saltier than the oceans. The very high levels of salt come from mineral-rich rivers and streams that run off the mountains into the lake. The heat of the desert causes the water in the lake to evaporate quickly, leaving the salt and minerals behind. Today, salt is removed from the lake and sold as an important commodity.

From the perspective of space, the bright red of mountain vegetation and human settlement stands out against the sparsely populated desert. Most of Utah's population is squeezed between the eastern mountains and the lakes. Salt Lake City, at the southeastern edge of the Great Salt Lake, merges into the city of Provo, on the eastern shore of Utah Lake. The land was first settled by the Mormons, members of the Church of Jesus Christ of Latter-Day Saints, in 1847. They transformed the desert with hard work and irrigation. Irrigation continues to make the eastern edge of Salt Lake Valley fertile.

The snow-covered peaks directly east of Salt Lake City belong to the Uinta Mountains, a segment of the Rocky Mountains. Kings Peak, at 13,528 feet, is the highest point in Utah.

Yellowstone

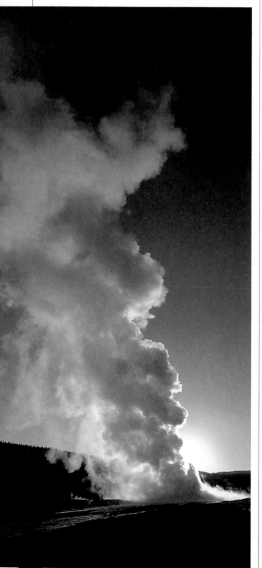

This view from space is too far away to capture the boiling, steaming, rumbling attractions of Yellowstone National Park. Taking up the northwest corner of Wyoming and crossing into Montana and Idaho, Yellowstone became the world's first national park in 1872. Best-known for its spouting geysers and grazing bison, the park preserves a unique geologic environment and is an important sanctuary for wildlife.

Yellowstone Lake, the big lake in the center of the image, is the largest lake in North America above 7,000 feet. The light blue line of the Yellowstone River curves northwest from the north shore of the lake. The park sits on top of the Continental Divide that separates rivers flowing east into the Mississippi River and the Gulf of Mexico from those running west into the Pacific. The Continental Divide zigzags from lower right to upper left, passing just beneath Yellowstone Lake.

The peaks, canyons, and lakes of Yellowstone were created over the past 2 million years by violent volcanic forces. Yellowstone sits inside a huge caldera, a collapsed crater so big, it can't be seen from the ground. Two chambers filled with magma lie beneath the caldera, and a column of hot rock goes

LEFT: *Old Faithful is not the biggest or most powerful of Yellowstone's many geysers, but it is the most dependable, erupting to heights of 100 feet and more every 40 to 80 minutes. Old Faithful has performed on schedule since it was first observed by trappers over a century ago.*

down 125 miles into the Earth's core. The heat from the rocks and magma is what causes geysers to erupt. Water collects in cracks underground and begins to heat up. Expanding steam forces the water upward, building pressure. When the balance between temperature and pressure reaches a critical point, the remaining water turns instantly into steam and shoots out of the ground. This spectacular display is repeated at dozens of spots throughout Yellowstone. Nearly two-thirds of the world's active geysers and hot springs are concentrated here.

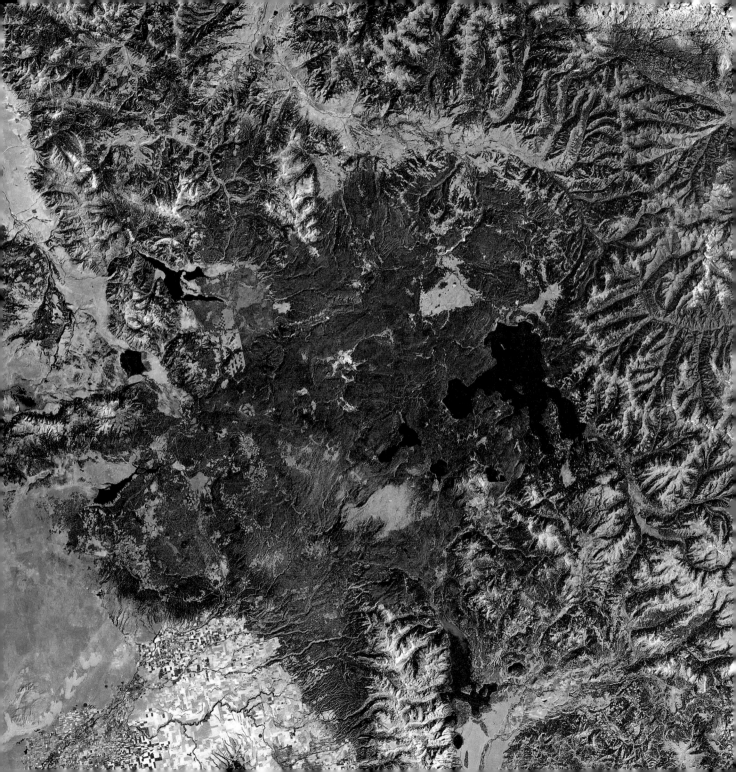

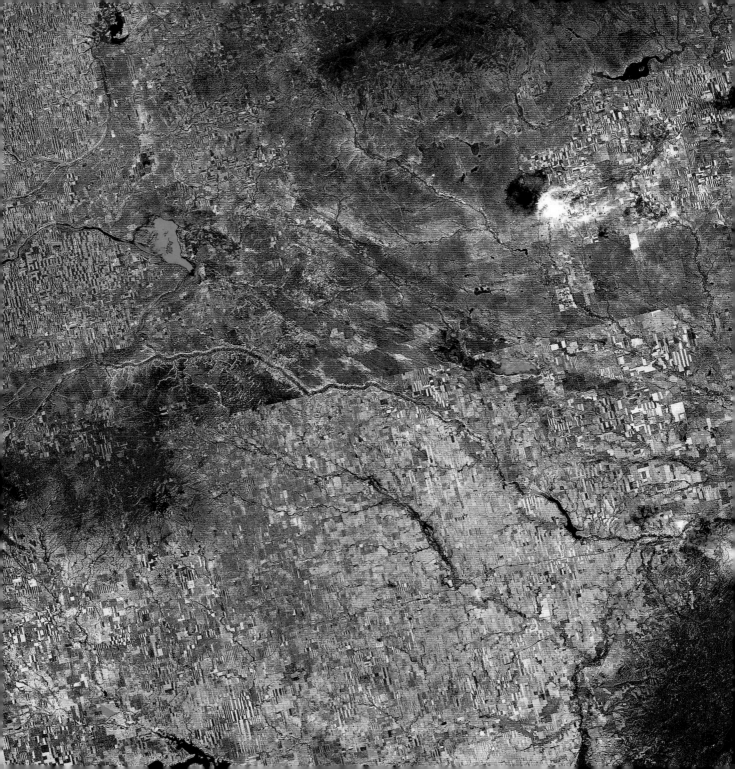

The Canada-Montana Border

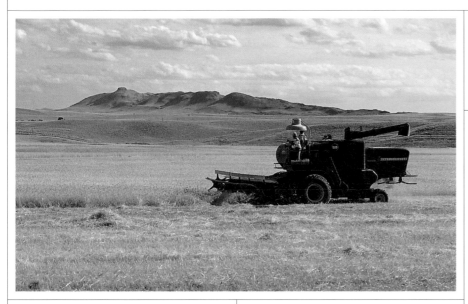

LEFT: *Wheat is the major crop grown in the Great Plains. Montana and the Canadian provinces produce a variety of hard red spring wheat that can withstand the severe climate.*

When the 49th parallel was chosen as the border between Canada and the United States in 1818, it was just a line on a map. Today, that line shows up from space, carved in the earth by the different ways people have used the land. In the Canadian provinces of Alberta and Saskatchewan to the north of the border, the land is used for grazing cattle, while Montana farmers to the south cultivate the land to grow wheat. The colorful checks represent different types of growth: healthy vegetation is red, newly harvested fields are white, and fields left to rest are light green.

Canadian rangeland is dark green.

The dramatic change between Canada and the United States has nothing to do with the soil and climate, as those are the same on both sides of the border. This area is part of the Great Plains, a high plateau that stretches from parts of Texas in the south to the Arctic Ocean. Once covered with tall grass, the Great Plains are characterized by rolling acres of loose silt, sand, and gravel fed by rivers and streams running east from the Rocky Mountains. The climate is dry and windy. In the United States, farmers tap into widespread aquifers, underground reservoirs of

water, to irrigate their land. Irrigation helps maintain healthy, productive fields despite the low rainfall.

Canada also produces high yields of wheat. The Alberta fields can be seen in the upper left of this picture. The Milk River curves southeast into Montana across the center of the image. The rare high spots in the plains stand out sharply. In the west, just below the Canadian border, are two black spots surrounded by red. These are the Sweetgrass Hills. Above the Canadian rangeland, the large red area marks the Cypress Hills. The big white smudges are clouds, and the identical black smudges next to them are cloud shadows.

St. Louis

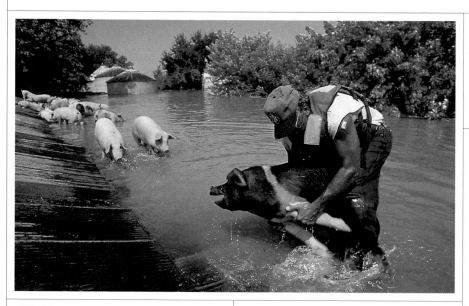

LEFT: *An Illinois sheriff wrestles with frightened pigs trapped on the roof of a barn. Fifty people and countless animals died as a result of the 1993 floods. Damage to property and crops was estimated at more than 10 billion dollars.*

Firrst settled as a fur-trading post in the 1700s, St. Louis, Missouri, has been blessed and cursed by the flow of water. The city, nestled beneath the confluence of the Mississippi River, on top, and the Missouri River, just below it, has been a transportation center since the days of the first steamboats. These satellite images illustrate the dramatic effects of flooding in the area. The inset picture shows the normal channels of the two rivers. After record-shattering rainfall in July 1993, both rivers left their banks.

The Mississippi River travels 2,350 miles from Minnesota to the Gulf of Mexico. Along its route, it collects water from 31 of the lower 48 states and parts of southern Canada. The river has long been a water highway, linking the cities and towns that line its banks. Barges carry tons of freight along its powerful current. The flat, fertile land is dotted with productive farms.

Almost every year, residents along the river battle its rising waters. Walls of gravel and dirt, called levees, some as high as 20 feet, have been built along the river. Locks and dams are maintained to control and divert swollen waters. These measures usually work well to protect cities and towns from normal high water, but under extreme conditions like the flooding in 1993, levees actually constrict water flow. Confined within artificial banks, the river runs faster and rises higher, putting more pressure on levees and locks downstream.

Scientists who study water movement argue that efforts must be made to restore wetlands along the river. The natural flood plain, land that is free of construction and asphalt, can absorb more water when rivers overflow. The U.S. government wants to buy back land along the flood plain of the Mississippi, but existing cities and towns will always be at risk from the raging river.

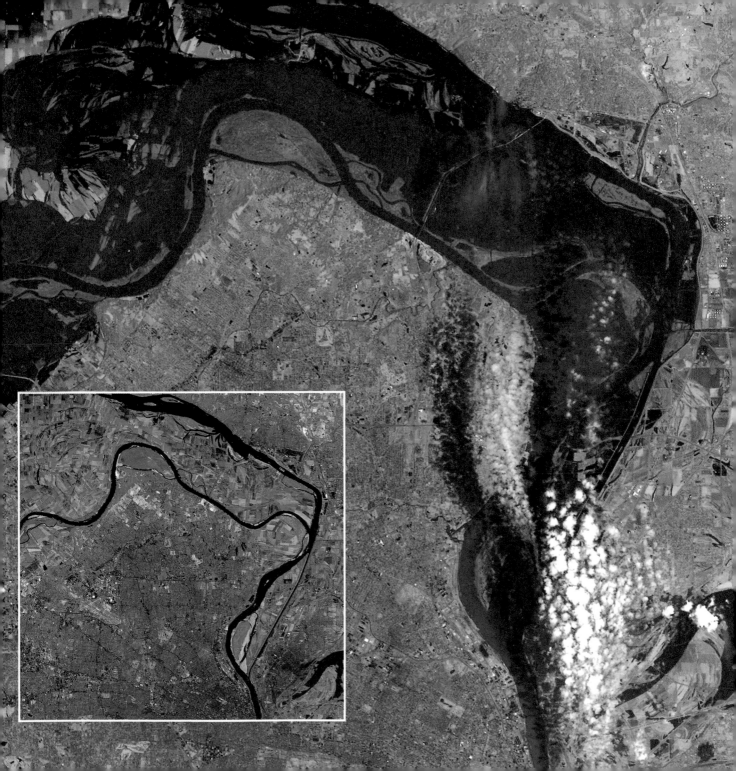

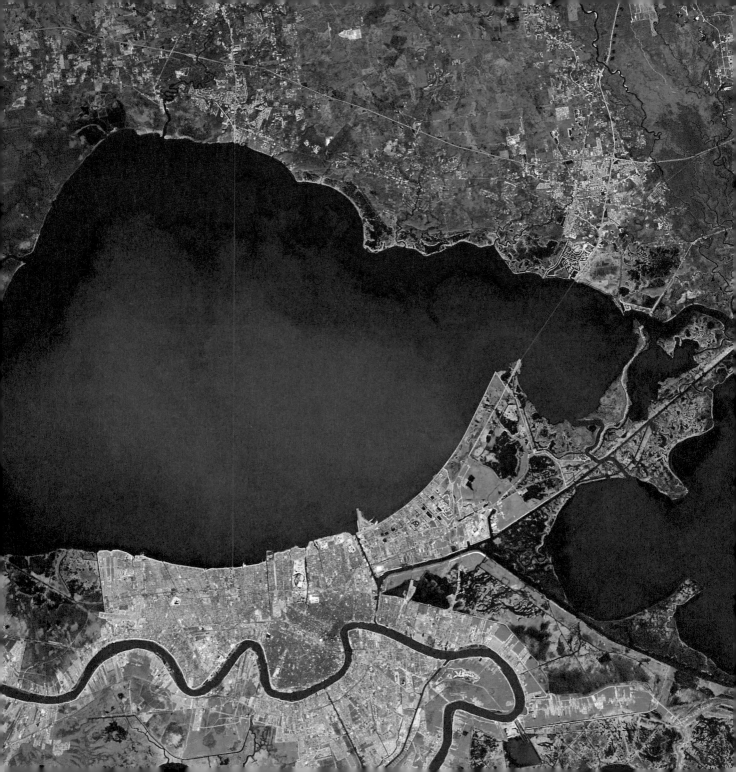

New Orleans

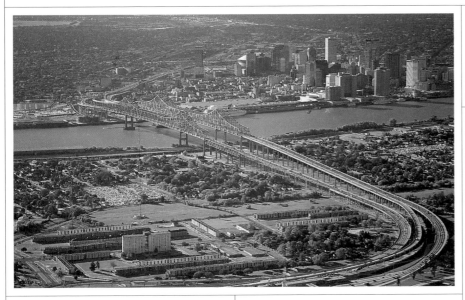

The city of New Orleans, Louisiana, pink in this satellite image, lies at the southern edge of Lake Pontchartrain. The faint line that shoots straight across the center of the lake is a 24-mile causeway, one of the longest bridges in the world. Below the lake, the Mississippi River winds through the city on the last leg of its journey to the Gulf of Mexico. Although a large commercial city, New Orleans is best known for Mardi Gras, a colorful festival held every winter. Tourists come from all over the world for the parties, parades, and jazz music.

New Orleans was first settled by the French in the 1700s. They built streets along a bend in the river, giving rise to the popular name "Crescent City." The original French Quarter remains the heart of New Orleans. It can be seen in the picture as the darker pink area to the left of the last sharp bend before the river turns south.

At five feet below sea level, New Orleans is the lowest point in the state of Louisiana. Natural and artificial levees help keep the Mississippi within its channel, but in some places, the river actually flows higher than the land around it. Huge ships and barges carrying cargoes from as far away as Minneapolis and Pittsburgh navigate the twisting Mississippi right through the middle of downtown. An important international port, New Orleans is lined with wharves and warehouses to accommodate the ocean-going ships that dock there. The thick blue line heading east away from the river is part of a system of channels that allows ships to shorten the trip to the gulf by 40 miles. A plan is under way to switch the port's activities away from the Mississippi River to an industrial complex on the Gulf of Mexico.

The Great Lakes

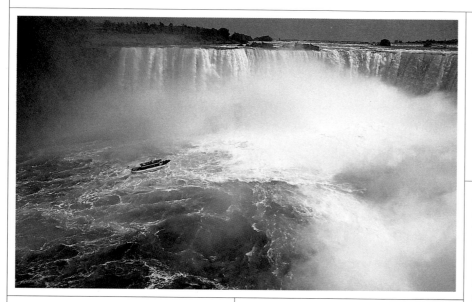

LEFT: *The waters of Niagara Falls plunge 182 feet into Lake Ontario. The falls originated about 8,000 years ago when a glacier receded and water started flowing out of Lake Erie to Lake Ontario over the Niagara cliffs. The rock underneath the thundering water continues to erode, causing Niagara Falls to move backward a few inches every year.*

The largest cluster of freshwater lakes in the world, the Great Lakes form a natural boundary between the United States and Canada. Early missionaries, amazed by their size, thought they were "sweetwater seas."

The Great Lakes stretch across 800 miles, starting with Lake Superior in the west and ending at the St. Lawrence River in the east. For years, children have been taught to identify the lakes by their shapes. From high in space, those whimsical shapes are especially clear. Lake Superior looks like a wolf's head. Lake Michigan looks like a squash plant with leaves. Lake Huron looks like a trapper bent under the heavy weight of his pack. Lake Erie is a lump of coal, and Lake Ontario is a carrot.

The Great Lakes were formed more than 10,000 years ago during the last ice age. Advancing glaciers carved deep basins into stream valleys. As the ice shrank back, it left deposits of sand and gravel that became the boundaries of the lakes. The melting ice also left the fertile soils that now support the Corn Belt. More than one-fifth of the nation's farm income is produced in the states that border the Great Lakes.

The Great Lakes drain into one another in a continuous flow. Waters from Lake Superior and Lake Michigan drain eastward into Lake Huron, then Lake Erie, and finally Lake Ontario. Economical shipping through the lakes gave rise to widespread industry and manufacturing in the region. Ships transport oil, iron, and coal for steel mills and factories. Since the completion in the 1950s of the Great Lakes Waterway – St. Lawrence Seaway system, ships can travel the 2,342 miles from the Atlantic Ocean to Duluth, Minnesota, in eight days.

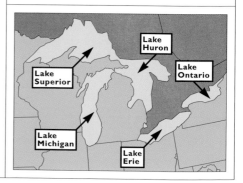

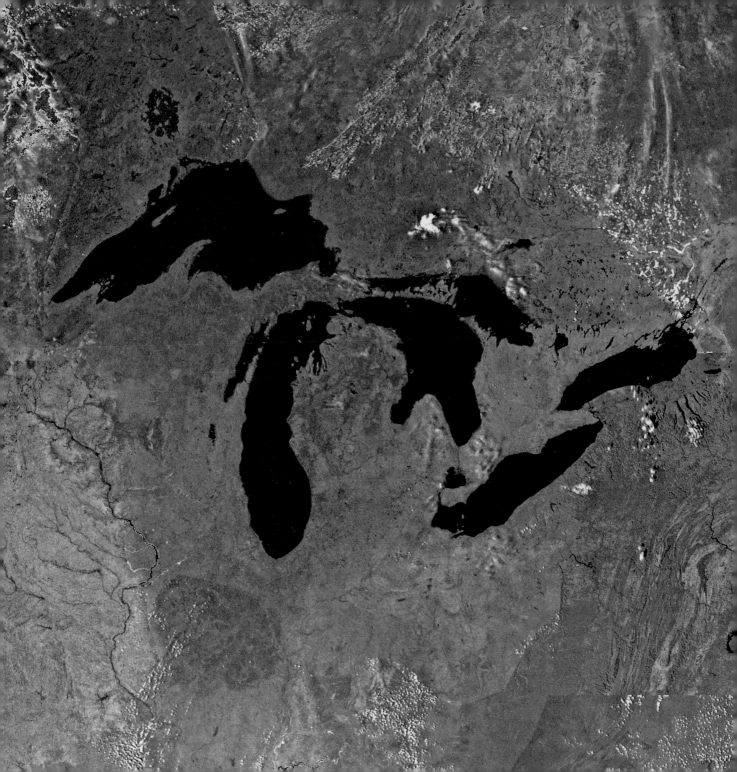

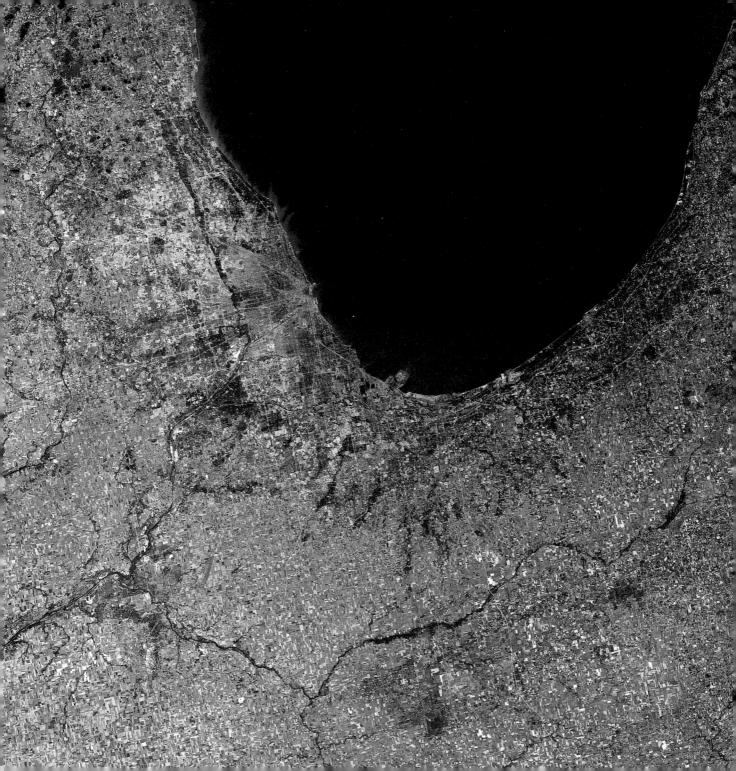

Chicago

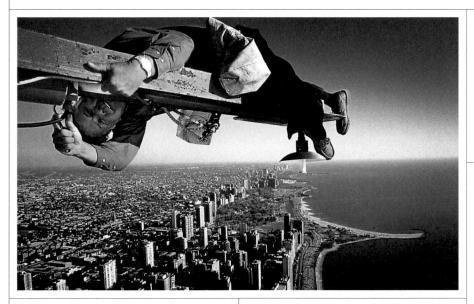

LEFT: *A workman with nerves of steel repairs an antenna on top of the Hancock Center. Chicago's famous skyline along Lake Michigan is visible beyond. The nation's first skyscraper was built here after the Great Fire of 1871 leveled the city. Now some of the world's tallest buildings tower over downtown Chicago.*

From a trading post at the muddy mouth of a Y-shaped river, the city of Chicago, Illinois, grew into one of the most important cities in North America. Chicago's strategic location on the southwest shore of Lake Michigan, and its access to water routes west, helped it become a major shipping center. It developed into the transportation hub of the Midwest, where cattle trains and grain ships converged. Today, Chicago is one of the world's richest commercial and industrial centers.

In the satellite image, the large blue patch on the western shore shows the greater Chicago area down to Gary, Indiana, at the southern tip of Lake Michigan. The center of Chicago radiates out from the mouth of the Chicago River, barely visible next to the tiny blue pier that juts into the lake. The river splits about a mile inland, beginning a series of waterways that divide the city into sections. Canals and channels were dug along existing rivers to connect Lake Michigan with the Illinois River, which flows west into the Mississippi. The large blue line that snakes southwestward from the lake is the Des Plaines River. The Chicago Ship and Sanitary Canal, built in 1900, runs beside it, flowing into the Illinois River at the city of Joliet.

The south shore of Lake Michigan is one of the most-concentrated industrial areas in the nation. Smokestacks from steel mills can cause severe pollution. Though population and industry cluster on the shoreline, a patchwork of fields and farms fills in the land beyond. Some of the richest farmland in the nation is here. The level fields are covered with thick, rich soil left behind by receding glaciers. Corn and soybeans are the principal crops.

The Finger Lakes

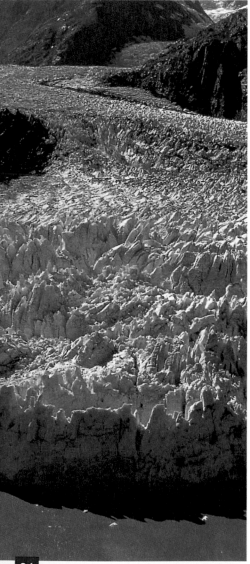

The Finger Lakes are spread across the countryside of western New York State, pointing toward Lake Ontario to the north. There are about a dozen of these long, narrow lakes, but the biggest of them, from west to east, are Canandaigua, Keuka (Y-shaped), Seneca (the largest), Cayuga, Owasco, Skaneateles, and Otisco. The Finger Lakes were carved by glaciers. In fact, the huge ice sheets that covered much of North America and Europe during the last ice age created more lakes than all the other geologic processes put together.

A glacier is a mass of ice that moves slowly over land. Glaciers form where there is a lot of snow that doesn't melt. The snow compresses into thick, grainy ice. As more snow falls, the ice beneath gets thicker and heavier. After years of this process, the grains of ice fuse into a solid mass that begins to move under its own weight. If the ice has formed in an alpine glacier on the side of a mountain, it will move slowly down the valley. If it is a sheet glacier, it will spread out from its center. Glaciers are very powerful. Like bulldozers, they push ahead, crushing and plowing everything in their

LEFT: *Most alpine glaciers move very slowly, barely a few inches a day. Since the bottom of a glacier moves faster than the top, the upper part of the ice fractures, causing cracks called crevasses.*

paths. They pick up and carry soil, rock, and debris, which are deposited when the glaciers eventually stop moving.

The Finger Lakes were once stream valleys that were roughly parallel. A sheet glacier dug them out, making them deeper and wider. As it shrank back, it deposited gravel and dirt, damming the lakes.

Today, the Finger Lakes region is a popular scenic area known for grape-growing and winemaking. The city of Rochester is the purple area beneath the southernmost dip of Lake Ontario. Syracuse is on the right edge of the image.

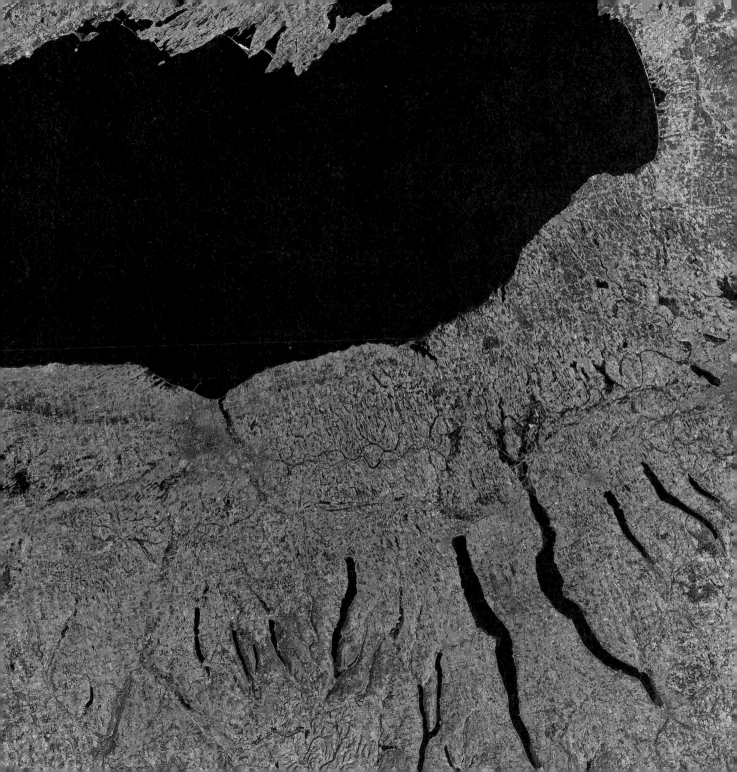

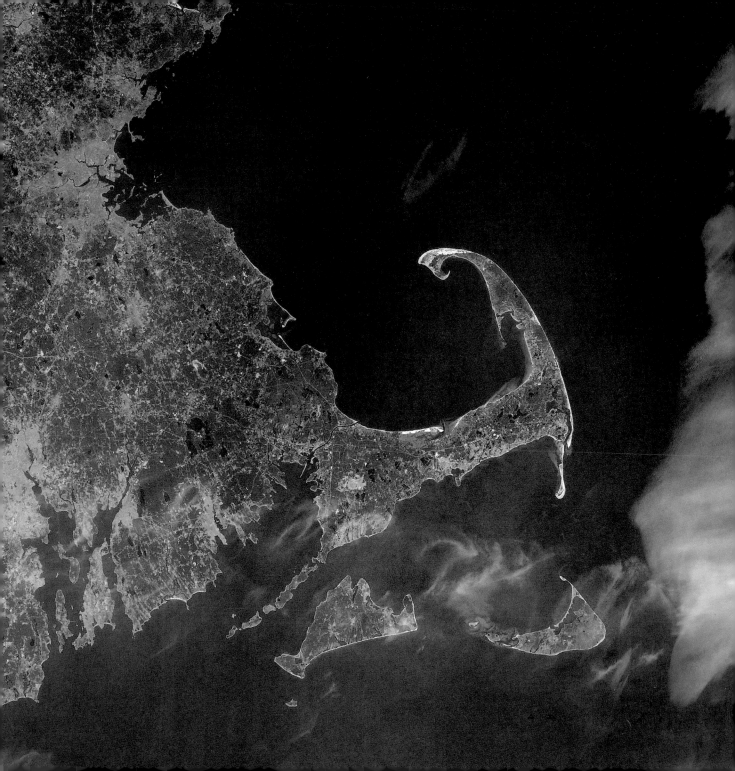

Cape Cod

Left: *Long, sandy beaches and high dunes make Cape Cod a popular retreat. Three wildlife refuges and the Cape Cod National Seashore preserve many miles of wild coast.*

Cape Cod is a giant hook of sand hanging off the eastern edge of Massachusetts. The peninsula extends 65 miles into the Gulf Stream of the Atlantic Ocean. It was named in 1602 by an English explorer who restocked his ship with "a great store of codfish." The Pilgrims landed at the tip of Cape Cod in 1620 before continuing to Plymouth Rock on the mainland.

Like so much of the land in New England, the rocky coast of Massachusetts was sculpted by sheet glaciers that covered the state in several thousand feet of ice. The area that is now Cape Cod was at the edge of a glacier. When the glacier retreated about 11,000 years ago, it left behind a pile of rocks, gravel, and sand called a moraine. Melting water from the glacier caused the level of the ocean to rise around the moraine, filling in low areas and forming a peninsula. Then wind, waves, and ocean current went to work, piling the sand into dunes along the coast and shaping the sandy spits and bars that give Cape Cod its distinctive smooth hook. The two islands beneath the cape, Martha's Vineyard on the left and Nantucket on the right, mark the southernmost edge of the glacier.

The thin, wavy line near the mainland is the Cape Cod Canal, a wide artificial waterway that connects Buzzards Bay in the south with Cape Cod Bay to the north. Opened in 1914, the canal allows ships to avoid the treacherous waters that surround the cape.

Boston is the large, light green area hugging Boston Bay on the Massachusetts coast north of Cape Cod. Providence, Rhode Island, on the Seekonk River at the head of Narragansett Bay, is visible on the south coast. The fuzzy green shape on the right edge of the image is a bank of high clouds.

New York City

The deep, sheltered harbor of New York lies where the Hudson River spills into the Atlantic Ocean. Crowded along this watery passage is New York City, the most populous city in North America. Millions of people live in and around the city, which is a busy port, a commercial center, and the financial capital of the world.

Even from space, the dense concentration of asphalt and buildings shows up in the overall blue of the image. Red vegetation is visible only in patches scattered around the city. The long, red rectangle in the center of Manhattan is Central Park, a green oasis in the middle of skyscrapers. Staten Island, the large island southwest of Manhattan, is considered a wilderness by many city dwellers for its acres of trees and parks.

The dark line of the Hudson River divides New York City on the east side from New Jersey on the west. Most people think that the island of Manhattan alone is New York City, but the city also consists of Brooklyn, Queens, the Bronx, and Staten Island. Called boroughs, the different sections are spread out on islands around the harbor. Only the Bronx, north of Manhattan, is part of the mainland.

Wharves and jetties stick out like the

LEFT: *Fireworks spotlight the Statue of Liberty during the Independence Day celebration in 1986. The statue, built to commemorate the friendship of the peoples of France and the United States, was dedicated in 1886. Facing toward the mouth of the harbor, the Statue of Liberty has come to symbolize the hope and opportunity offered to immigrants who enter the United States.*

teeth of a comb along the west side of Manhattan, evidence of its long history as a major port. Other shipping facilities are across the bay on the New Jersey shore. At the southern tip of Manhattan is Governors Island. Straight west of that is Liberty Island, the small island where the Statue of Liberty watches over New York Harbor. Just above Liberty Island, connected to New Jersey by a pier, is Ellis Island, where millions of immigrants entered the United States between 1892 and 1943.

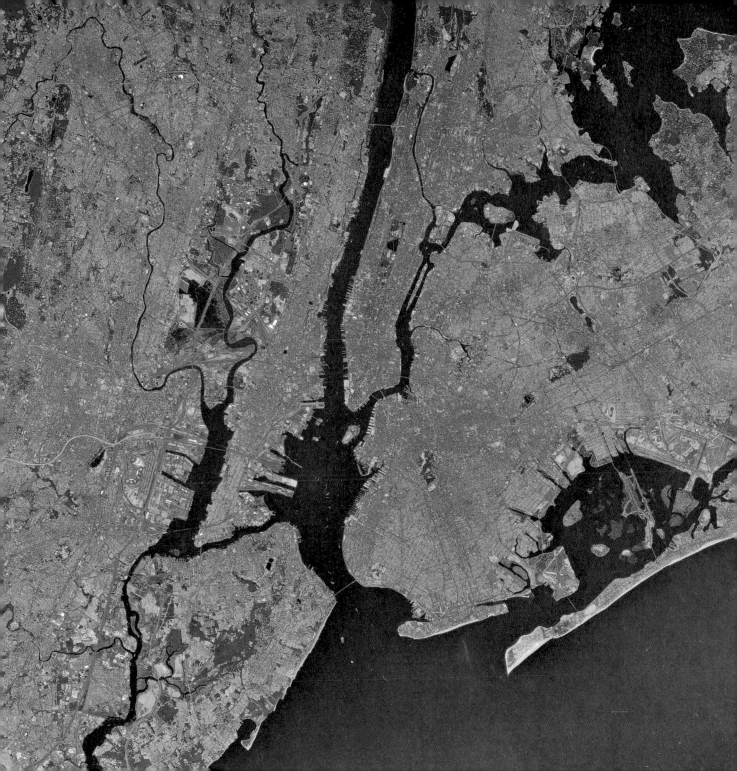

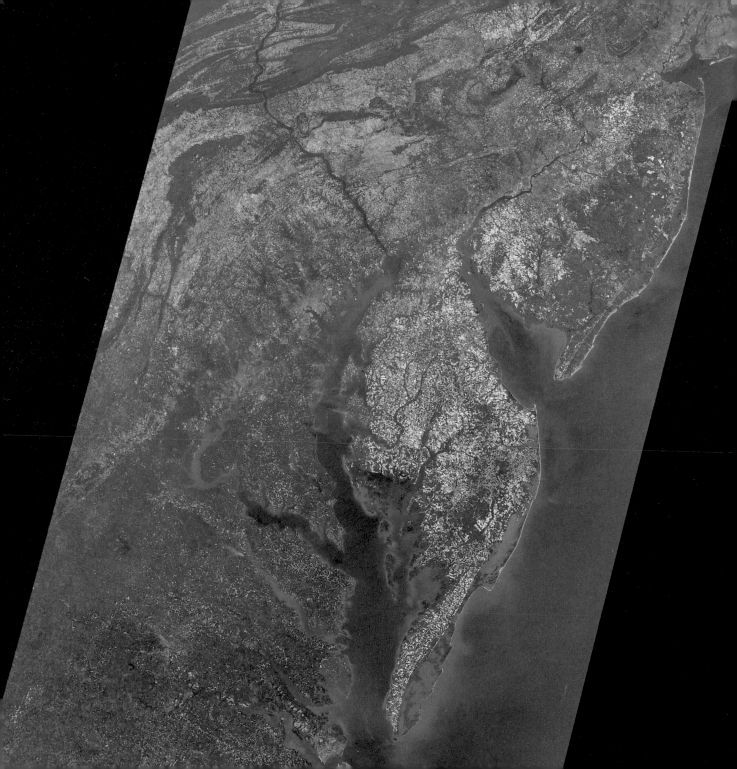

The Chesapeake Bay

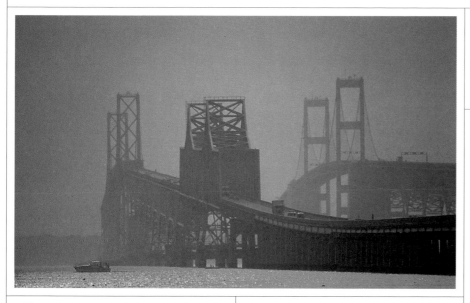

Like the claw of a giant crab, the Delmarva Peninsula forms the eastern shore of the Chesapeake Bay. The name Delmarva comes from the three states that share it — Delaware, Maryland, and Virginia. Enclosed by the peninsula, the Chesapeake Bay is the largest estuary in the nation.

The bay mixes fresh water from hundreds of rivers and streams with salt water from the Atlantic Ocean, creating special environments for plants, fish, and shellfish. The tidal wetlands around the edge of the bay show up turquoise in the satellite image. These shallow areas are feeding grounds for waterfowl and wading birds. They also shelter oysters, clams, and blue crabs, favorite delicacies of hungry humans.

In the deeper waters, dark blue in the picture, marine life thrives. Chesapeake watermen harvest half a billion pounds of seafood every year.

The many colors dotting the Delmarva Peninsula represent its wetlands, parks, farms, and houses. Each fall, the peninsula acts as a giant funnel for millions of migrating birds as they fly south. The birds stop to refuel at the southern tip before attempting to cross the wide water at the mouth of the bay. Some swallows and songbirds fly as far as 2,000 miles to South America, while flocks of ducks and geese spend the winter in the bay.

High above the Earth, the satellite is able to pick up what the human eye misses: the thousands of square miles in six states that drain into the vast Chesapeake Bay. At the very top of the bay is the Susquehanna River, the purple ribbon zigzagging northward through Pennsylvania to its source in New York State. The bay depends on clean, fresh water to sustain its rich ecosystem. Human development, especially the demand for waterfront property, raises worries about growing pollution and its effect on marine life.

Washington, D.C.

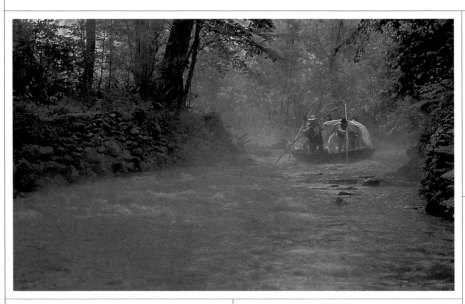

LEFT: *A vision from the 18th century, canal buffs pole a reproduction of a 50-foot riverboat through a remnant of the Patowmack Canal. Hoping to connect eastern communities with the western frontier, George Washington founded a company to build a canal along the Virginia side of the Potomac River. Although five locks operated around Great Falls, unreliable water levels caused the canal to close in 1830.*

Flowing from its source in the Appalachian Mountains, the Potomac River carves the border between Maryland and Virginia. The city of Washington, D.C., is visible as a dark blue area of neatly grided streets tucked between the Potomac and the Anacostia Rivers.

The nation's capital was a planned city, built on a site chosen by George Washington, who had explored the Potomac from the Chesapeake Bay to its source. The city was situated just below the fall line that divides the Piedmont Plateau from the Atlantic Coastal Plain. Since this was the last navigable stretch of the Potomac, the capital was open to sea trade, but its location inland protected it from large-scale sea attacks. As the nation grew, however, the push westward was hampered by falls that made shipping upriver impossible. The Chesapeake and Ohio Canal was built between 1828 and 1850 to bypass the river and move traffic more easily. The canal ran parallel to the river on the Maryland side for 184.5 miles.

In the satellite picture, the Great Falls show up at the left edge as a bend in the river where water flow is constricted into a thin, wavy line. At this point 10 miles above Washington, the river builds tremendous speed and force as it falls over steep rocks and rushes through a narrow gorge. The canal is barely visible as a line along the north shore.

Landmarks of the nation's capital are also recognizable. The dark cloverleaf at the base of the city is the Tidal Basin, where the Jefferson Memorial is located. Just above it is the Mall, a series of green rectangles that runs between the river and the U. S. Capitol.

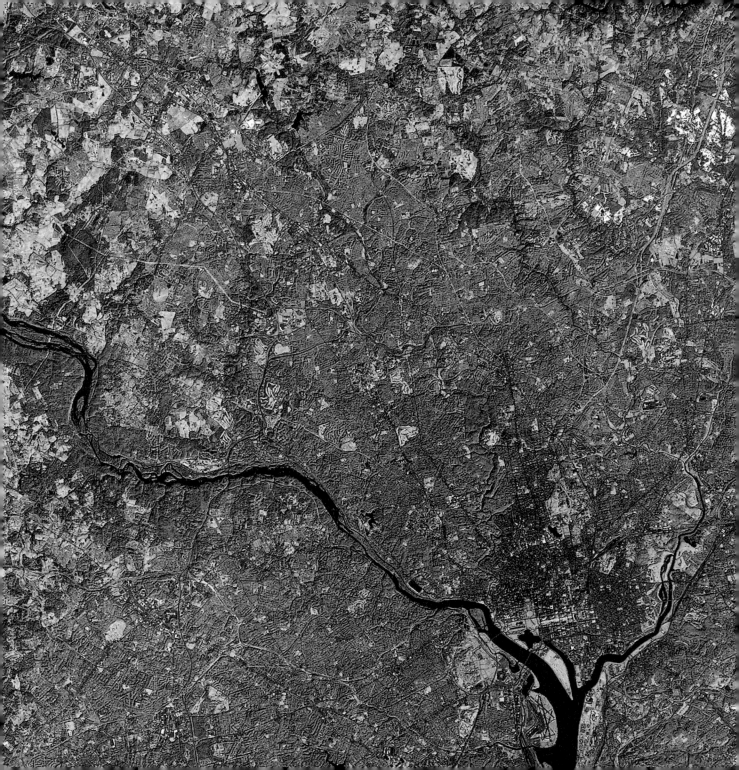

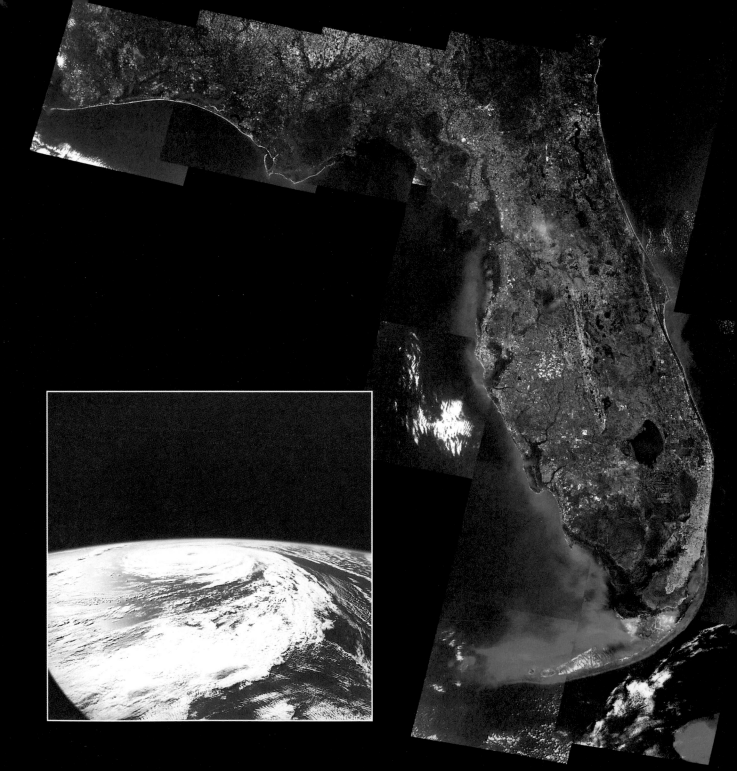

Florida

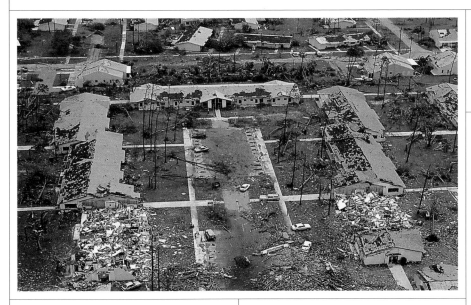

INSET: *High above the Atlantic Ocean, clouds are sucked into Hurricane Florence as it heads toward Bermuda in 1994.*
LEFT: *Hurricane Andrew hammered South Florida in 1992, causing widespread damage.*

with winds up to 73 miles an hour. When the winds increase above 74 miles an hour, the storms are classified as hurricanes. Winds may blow at more than 200 miles an hour.

Every year, dozens of hurricanes threaten the Florida coast. Most don't hit land, but those that do destroy everything in their path. Raging winds tear down buildings, pouring rains cause floods, and rising waves pound the beaches. The safest strategy for survival is to evacuate the storm area. Scientists rely on satellite images to help them determine the course and the force of hurricanes. Accurate predictions can save thousands of lives.

M illions of years ago, Florida was at the bottom of the sea. Today, Florida is a vacation wonderland only a few feet above sea level. This picture of the entire state, pieced together from satellite views, shows the Florida Peninsula projecting 400 miles into the sea. The Atlantic Ocean borders it on the east and the Gulf of Mexico on the west. With its many bays, inlets, and islands, Florida has 8,426 miles of shoreline. A chain of islands called the Florida Keys extends off the southern tip. Lake Okeechobee, the source of water for the Everglades, is the large circle near the bottom. The city of Miami hugs the southeast coast. St. Petersburg and Tampa show up as a dusting of white around Tampa Bay, the dark inlet in the middle of the west coast. Orlando is near the center of the state.

Because Florida is low, flat, and surrounded by sea, the entire state is susceptible to the devastating forces of hurricanes. Most hurricanes form in the summer or fall when the temperature of the ocean is warmest. As the sun heats the water, it rises and cools, forming rain clouds. The rotation of the Earth starts to spin the clouds, sucking more moist air up into a growing whirlwind. Some of these develop into tropical storms

The Everglades

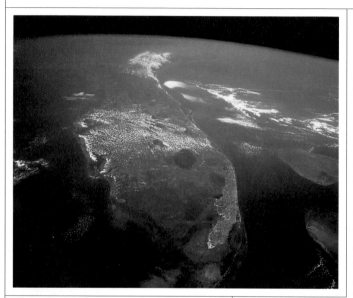

A patchwork of many colors, the tip of Florida barely floats above the surrounding water. Few places in the world are lower and flatter. Here, the Everglades, a wet, grassy marsh, stretch from Lake Okeechobee in the north, the black pool at the top of the picture, to Florida Bay and the Gulf of Mexico in the south. During the summer wet season, the Everglades become a "river of grass," as fresh water flows slowly through the tough sawgrass on its way south. In the winter season, it is a dry grassland dotted with mudholes.

The satellite image clearly shows the competition that is taking place for land and water in South Florida. The bright green rectangles just south of the lake are the many farms that grow sugarcane and tomatoes on the rich soil from drained marshes. Along the eastern coast, the city of Miami sprawls as people move there to enjoy the warm climate and sunny beaches. Farmers, homeowners, and vacationers all need water. Canals divert water away from the Everglades into city waterpipes and farm irrigation systems. The waterways show up as diagonal red lines between Lake Okeechobee and Miami.

With the water flowing away from the marsh, the fragile ecosystem of the Everglades is in peril. Everglades National Park, the vast green and red area to the left of Miami, preserves the undeveloped wilderness that remains. Though best known as the swampy home of alligators, the park protects a number of unique habitats. Water level determines what grows where. The red teardrops that flow down the dark center of the picture are hammocks, tiny hills — some only a few inches higher than the marsh around them — that allow hardwood trees to grow in dense stands. When seen from space, the shape and position of the hammocks demonstrate how water sweeps across the Everglades toward Florida Bay. Mangrove forests, shown in deep red on the bottom of the image, grow in the channels and winding rivers along the coast.

As human activity continues to disturb the delicate balance of the Everglades, satellite images will help us keep track of the changes.

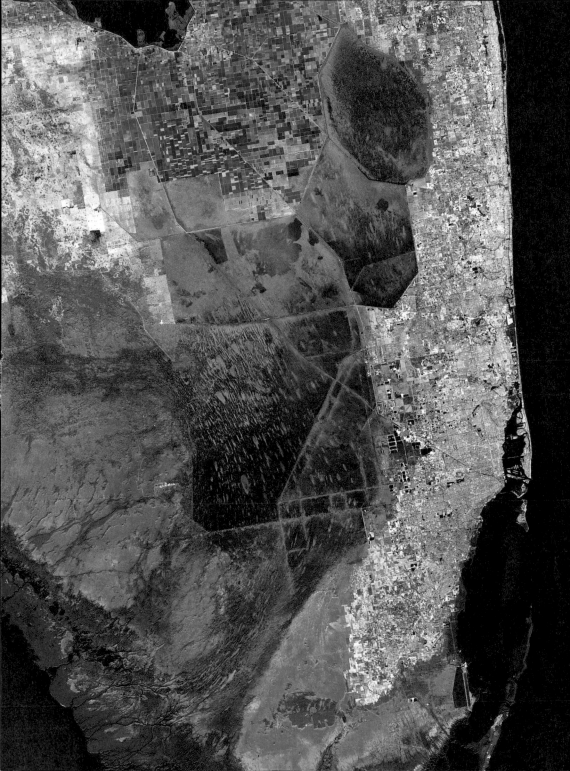

Illustration Credits